CHICHESTER

HISTORY TOUR

Map contains Ordnance Survey data © Crown Copyright and datatbase right [2015]

First published 2009
This edition published 2015

Amberley Publishing
The Hill, Stroud,
Gloucestershire, GL5 4EP
www.amberley-books.com

Copyright © Philip MacDougall, 2015

The right of Philip MacDougall to be
identified as the Author of this work
has been asserted in accordance with
the Copyrights, Designs and Patents
Act 1988.

ISBN 978 1 4456 5438 6 (print)
ISBN 978 1 4456 5439 3 (ebook)

British Library Cataloguing in
Publication Data.
A catalogue record for this book is
available from the British Library.

Typesetting by Amberley Publishing.
Printed in Great Britain.

INTRODUCTION

In terms of its city status, Chichester, replete with its still-existing major thoroughfares, was planned and executed by the Romans. It was the Romans who created the vast defensive walls that encircled and marked the outer limits of the city while also establishing the grid pattern of roads that still fundamentally exists within the area of the walls. From the time of the Romans onwards, the city has been allowed to muddle through. Where consistency and planning is discernible it is often a result of being forced to follow that original Roman template, so ensuring that the central area of the city remains spacious, airy and generally uncluttered.

It is, therefore, fortunate that Chichester was a direct product of Roman engineering and the accompanying civic pride that was so much a feature of that particular autocratic period of governance. If it had been otherwise, then any emerging township in this same geographical location would undoubtedly have been a ramshackle and overcrowded mess that would have left each subsequent generation demanding the destruction of all that had gone before. Consequently, developers would have been given a green light to crowd into a vastly reduced area of space a number of cheap properties that would have been inappropriate to the real needs of those who inhabited the city. In turn, such buildings would have offered little to any future heritage industry, being nothing less than a ghastly blot on the landscape.

Not to get too hung up on the Romans, there was another important factor that worked to the advantage of the city during its period of early growth. The Romans, through the construction of those defensive walls, had clearly established a city of size and spaciousness that had the opportunity to breathe and expand. Into the north-west quadrant, following close upon the invading Normans, came the established Church in all its glory. Taking virtual full possession of this area of the city, the Church applied similar design standards to those previously laid down by the Romans. With a number of buildings, both aesthetically pleasing and substantial in nature,

they set such high standards that others must have felt the need to strive and reach out for a similar level of absolute perfection. Such buildings that might not have otherwise existed include both Ede's House and Pallant House.

Unfortunately, the light-touch approach to the control of developments within the city has become an ideological fact of everyday life within the city. Rather than plan the city for the needs of its citizens, muddling through is still the predominant policy of choice. For far too long, the planners of the city have given in to the wishes of the developers and, more recently, the demands of the motorist. In accepting that people need mobility, it is not necessary to strangle the city and destroy that freedom of movement that a well-planned city should possess. This failure to take a firm hand has, through much of the twentieth century, resulted in the needs of the motor car being the prime factor that underpins most modern developments in the city. Now, with rising oil prices caused by the approach of peak oil supply, there has never been a better time to reverse this trend.

Perhaps the factor that has allowed the dominance of the motor car to continue is that of both district- and county-wide administrative bodies having full control over all planning and highway matters that directly affect the city area. With only a small minority of their respective members being city-based, they are themselves dependent upon the car for travelling into the city. As such, they share few of the frustrations of those, in the majority, who access the city through the use of public transport, cycles or walking. Buses, from many areas, are infrequent, while walking anywhere beyond the two semi-pedestrianised main streets is much akin to playing Russian roulette. Furthermore, the dangers imposed upon the pedestrian are greatly increased by the encouragement of cars into the city area through the existence of comparatively cheap inner-city car parks and the ease of using nearby roads as an alternative to the outer by-pass.

Those on the District and County Council responsible for planning the future of the city should take a long, hard intake of breath and look at progressive developments taking place in other historical towns of similar size.

ACKNOWLEDGEMENTS

Most of the illustrations used in this book have been drawn from my own collection of photographs that has been built up over a number of years. In addition to these, I would like to thank Mrs Cecily Williams, the former Shippam's Co. Ltd and the late Mr Douglas Cecil for the loan of these photographs.

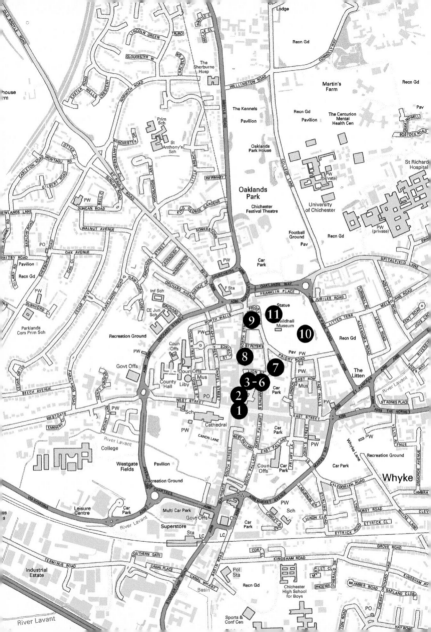

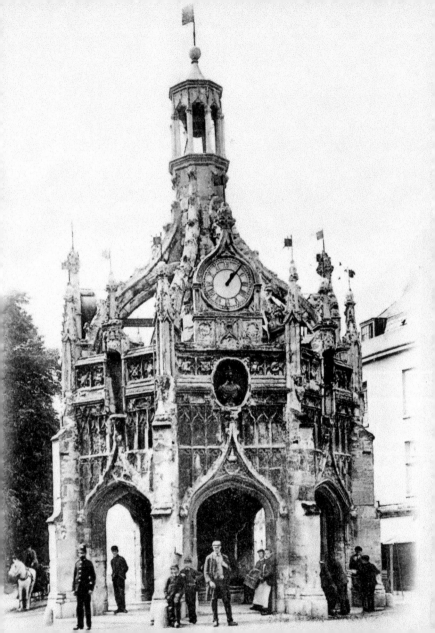

1. THE MARKET CROSS

The Cross, which stands at the very centre of Chichester, was the original shopping experience. Constructed in or around 1501, it was given to the city by Bishop Edward Story (1478–1503) as a facility for traders who were too poor to pay the normal market fees. Under the terms of its foundation, traders who were permitted to use it were not only protected from the elements but were not to be subject to any charges whatsoever. Within the niche a bust of Charles I is visible, and this is now replaced by a fiberglass replica. Where the Cross is viewed from South Street, the earlier view dates to the turn of the century and is dominated on the right by the awnings of Charge & Co., a drapery store and ladies' outfitters that occupied this particular site for much of the twentieth century.

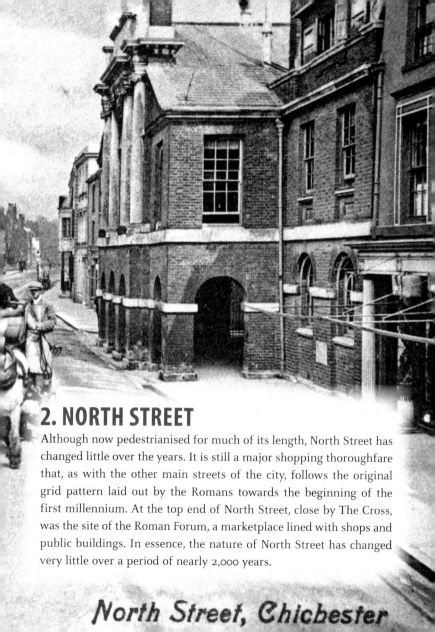

2. NORTH STREET

Although now pedestrianised for much of its length, North Street has changed little over the years. It is still a major shopping thoroughfare that, as with the other main streets of the city, follows the original grid pattern laid out by the Romans towards the beginning of the first millennium. At the top end of North Street, close by The Cross, was the site of the Roman Forum, a marketplace lined with shops and public buildings. In essence, the nature of North Street has changed very little over a period of nearly 2,000 years.

North Street, Chichester

3. THE BUTTERMARKET

Originally known as the Market House, the Buttermarket in North Street, seen to the right of this picture, as originally constructed in 1807, was to provide an enclosed trading area that would replace the Market Cross. Originally a single-storey building, the upper storey was added in 1900. During the earlier part of the twentieth century, the Buttermarket housed both the local public library and the Chichester School of Art. Following extensive refurbishment, it was reopened in April 2011.

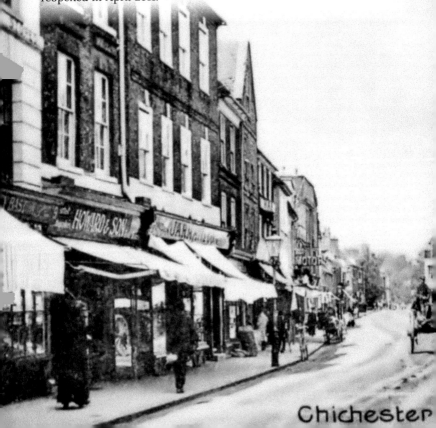

Chichester

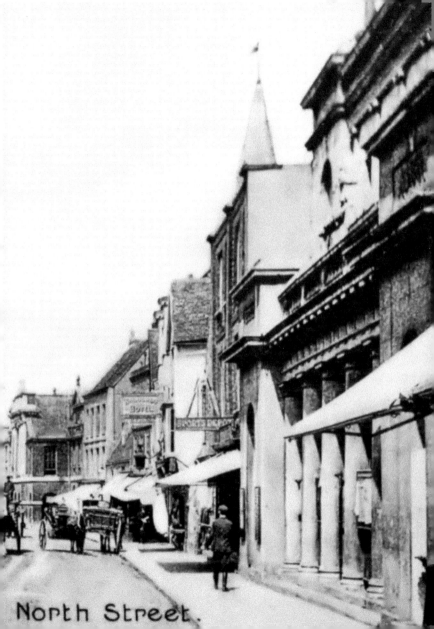

North Street.

4. ST OLAVE'S CHURCH, NORTH STREET

The former church of St Olave, now a bookshop, is a reminder of the age of this particular street, St Olave's possibly has its origins in the eleventh century.

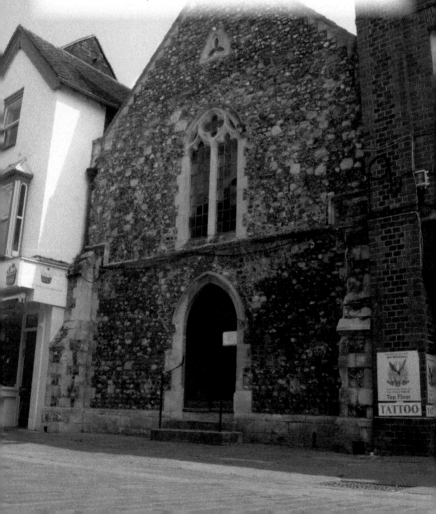

5. CROOKED 'S'

Distinctly downmarket at the outset of the twentieth century, the Crooked 'S' off North Street was once a narrow passage that gave access to a number of small and cheap homes. While the passageway still exists, and it is possible to see where the original doorways and windows once stood, the buildings lining this passageway are used as extensions or storage areas for nearby business premises.

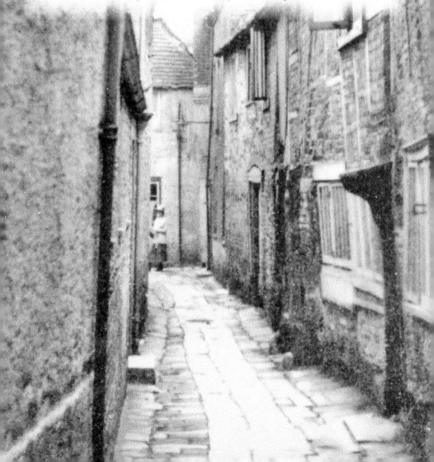

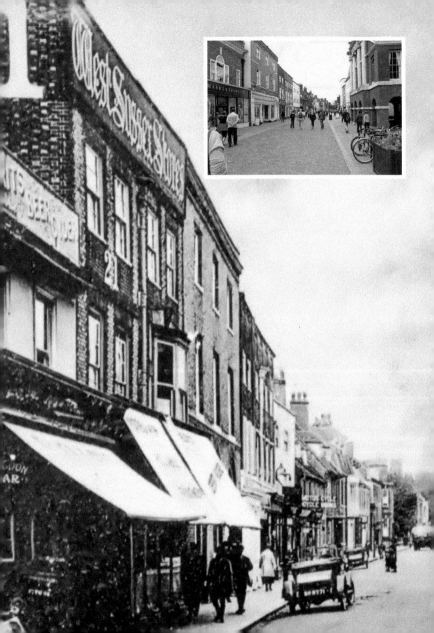

6. COUNCIL HOUSE

The photograph, *c.* 1929, taken well before pedestrianization was dreamed of, has several buildings of interest, including the Council House on the right. On the left, and clearly marked, is the West Sussex Stores (later the site of John Perrings Furnishings) while the adjacent store (moving towards the camera) was a wine and spirit merchant run by Tyler & Co.

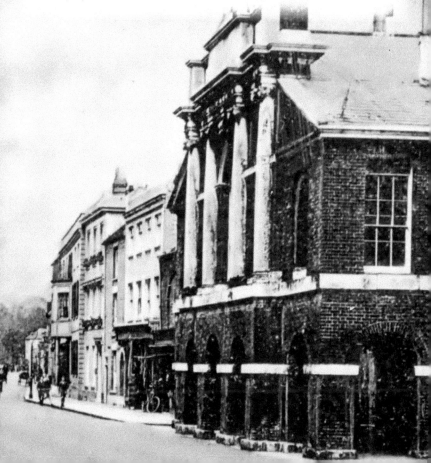

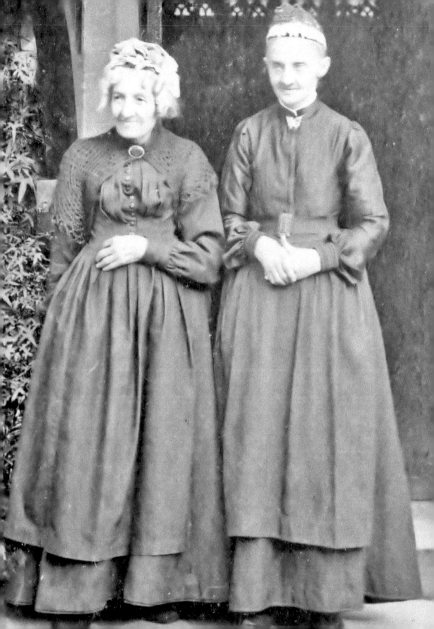

7. ST MARY'S HOSPITAL ALMSHOUSE

Situated in St Martin's Square, and reached by way of Lion Street (next to the Council House), are a group of houses that are part of the St Mary's Hospital Almshouse complex. The complex has existed in this area of Chichester since the thirteenth century, having been established for the care of the sick and for those in poverty who needed overnight accommodation. By the sixteenth century this role had altered to that of providing permanent rather than temporary care, with housing given over to the elderly who had little means of support. A particular building of importance which stands within the complex is a thirteenth-century barn-like structure that, during the seventeenth century, was converted into eight single-bedroom flats. On this page, two of the permanent residents of the complex, Miss Redman and Miss Pearce, are seen on the occasion of being presented to King Edward VII at the time of one of two visits he made to the almshouse complex, these being in 1906 and 1908.

THE HOSPITAL OF THE BLESSED VIRGIN MARY FOVNDED A.D. 1158–1170 REMOVED TO THIS SITE ABOVT 1253.

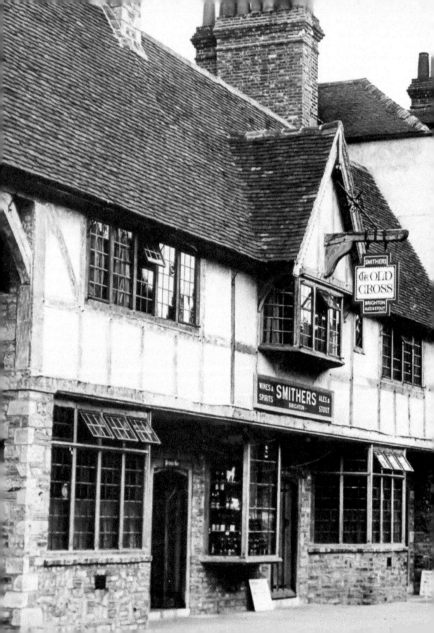

8. THE OLD CROSS

Further along North Street (on the east side of the street) can be found the Old Cross. Following a fire on this site, the present building was constructed in 1928. Admittedly it gives the appearance of having been built in Tudor times, but this is far from being so. The building further along, the North House Hotel, was itself replaced by a new building in 1936.

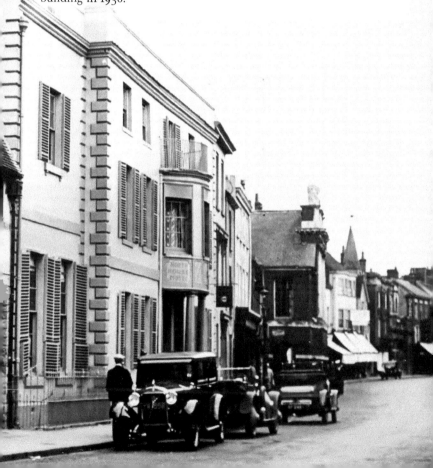

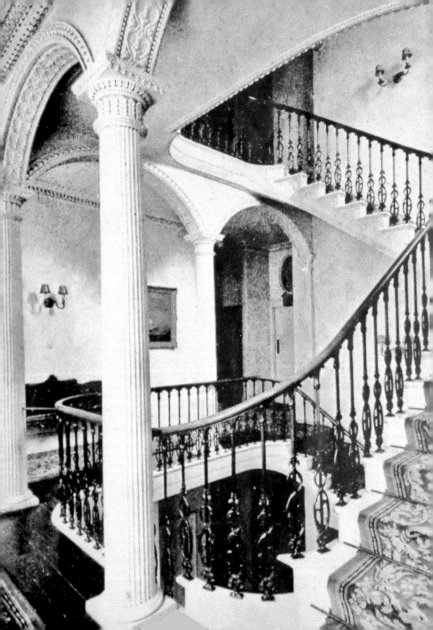

9. SHIP HOTEL

At the far end of North Street is the Ship Hotel, built by Admiral Sir George Murray sometime around 1790. Of particular interest is a fine internal staircase in the style of Adam, seen here in a photograph taken during the middle years of the twentieth century. Murray was a noted naval officer who fought alongside Nelson at the Battle of Copenhagen.

10. PRIORY PARK

Priory Park can be approached by way of Guildhall Street and which is immediately alongside the Ship Hotel. Chichester has often been described as a quintessentially English city, and what could be more quintessential that a quiet afternoon of cricket in the local park. The scene here is Priory Park during the early twentieth century, but come to this park on most Sunday afternoons in summer and the scene is easily replicated. Indeed, cricket has also been played here at both international and county level, with a touring Australian team playing here in the 1880s. Behind the cricketers is the Guildhall, while Priory Park is also home (on the north side) to a large mound (or motte) that was once topped by a Norman castle.

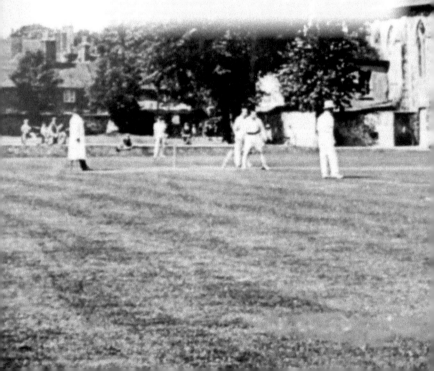

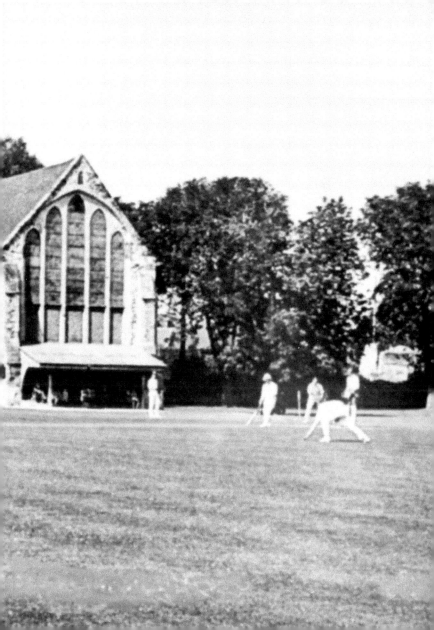

11. GUILDHALL

This image of the Guildhall in Priory Park dates back to the reign of Queen Victoria. The Guildhall itself is the only surviving section of a former Franciscan friary that dates to the thirteenth century. Following the dissolution of religious houses by Henry VIII, the building was given to the mayor and citizens of Chichester and subsequently used for a variety of purposes, including that of a courthouse.

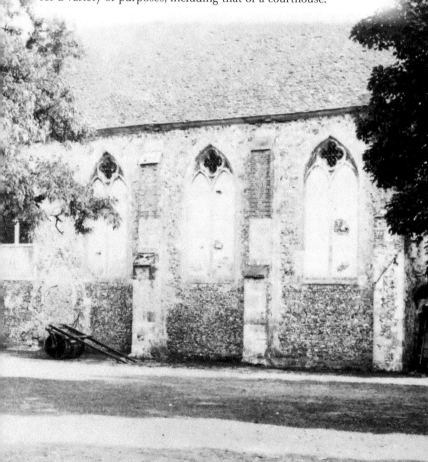

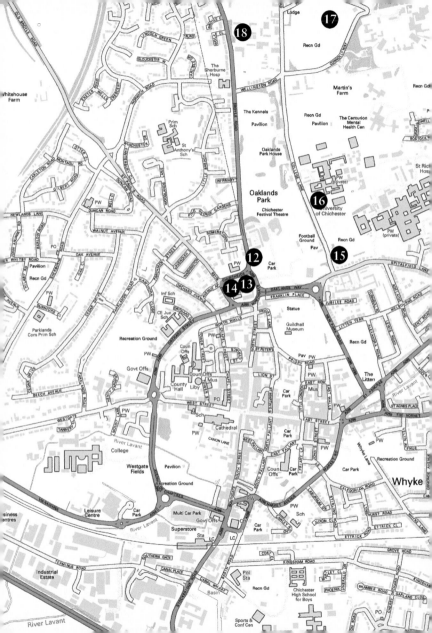

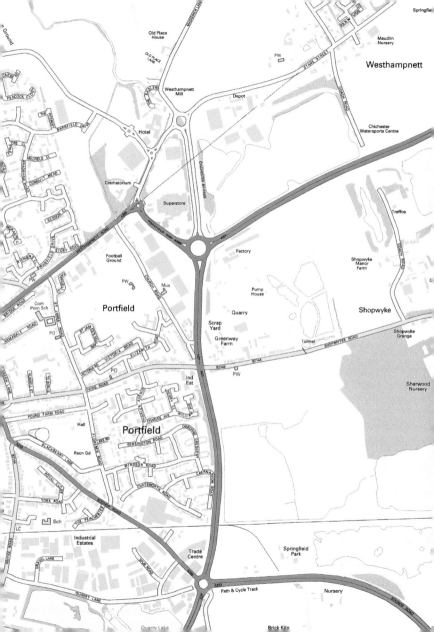

12. CHAPEL OF ST BARTHOLOMEW'S HOSPITAL

The exterior view (*inset*) of St Bartholomew's Hospital chapel in Broyle Road was taken sometime around 1909. In origin it was part of an almshouse for the maintenance of 'twelve decayed tradesmen' founded by Sir William Cawley in 1625. During the Civil War Sir William, who was at that time the Member of Parliament for Chichester, supported the Parliamentary cause, with his signature one of those placed on the death warrant of Charles I. The memorial to Sir William's father, John Cawley, is located in the cathedral and makes mention of the son, referring both to the almshouse he established and of his signing the King's death warrant.

13. OLYMPIA SKATING RINK

Now isolated in the middle of a large roundabout on the north side of the city, this might give the appearance of being a long-neglected insubstantial building. Indeed, it was once the city's first purpose-built cinema with an adjoining roller skating rink. The cinema was opened in 1911 and closed in February 1922 following a fire. The first film shown, a silent movie entitled *Judas Maccabaeus*, although a blockbuster in its day, was generally considered to be a travesty of historical authenticity.

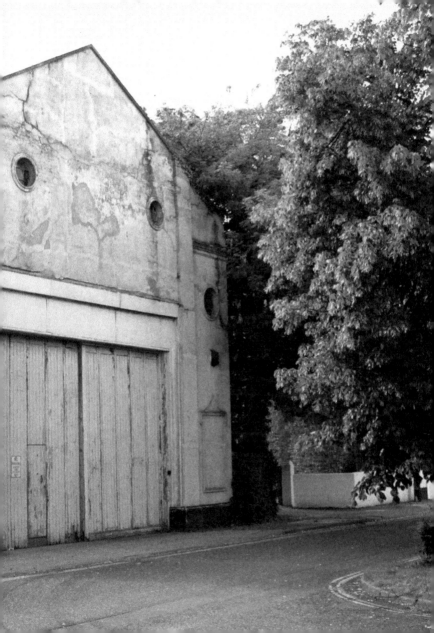

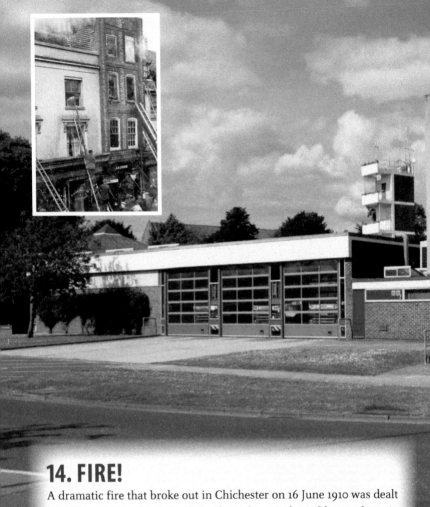

14. FIRE!

A dramatic fire that broke out in Chichester on 16 June 1910 was dealt with both by the local fire brigade and a number of bystanders. At that time the fire station was located close to the present-day Market car park, while today it stands in Northgate.

15. LOVE LANE

Once a quiet road with a few residential houses along its length, it is now a somewhat busy 'country' lane that gives access to the university. However, the original thatched cottage, on the edge of the university grounds, still exists. Oh, and the road itself is now College Lane.

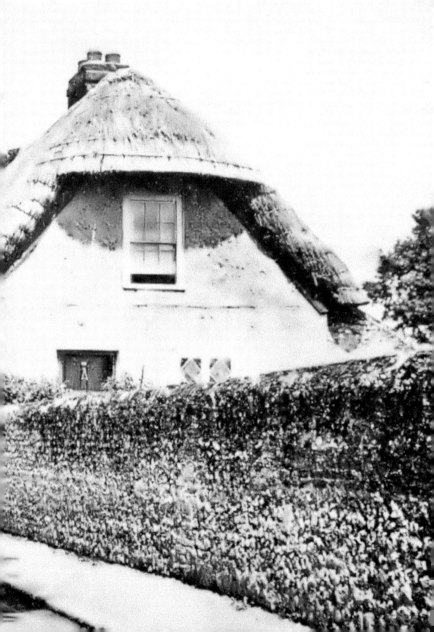

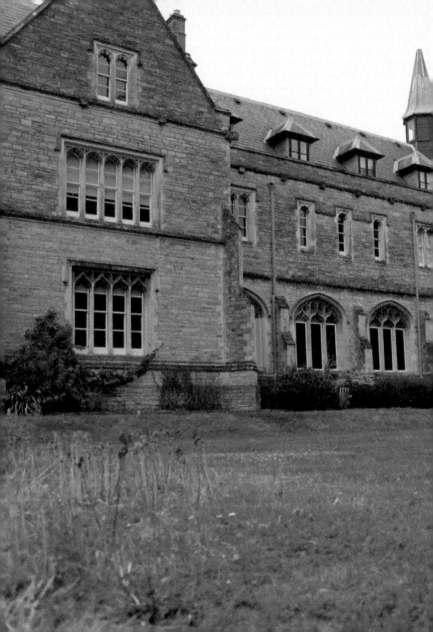

16. BISHOP OTTER COLLEGE

Situated in College Lane, Bishop Otter College is now the site of Chichester University, having originally been established in 1840 as a training college for teachers. Bishop Otter himself had been greatly involved in education and the naming of this Church establishment was designed to serve as a permanent memorial to his name. It was in October 1850 that the college actually moved to its present site; it was restyled as university in 1995, with many of the original buildings still in use.

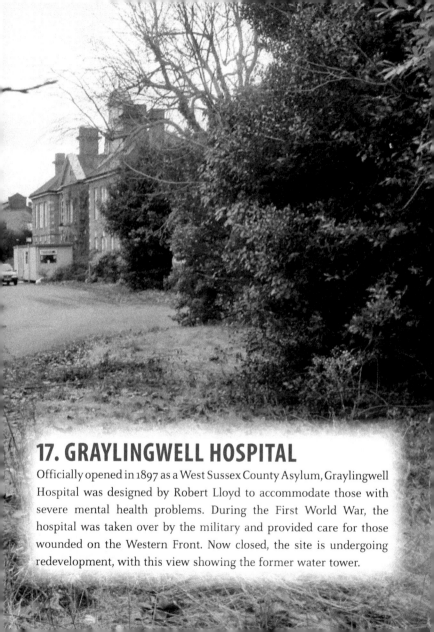

17. GRAYLINGWELL HOSPITAL

Officially opened in 1897 as a West Sussex County Asylum, Graylingwell Hospital was designed by Robert Lloyd to accommodate those with severe mental health problems. During the First World War, the hospital was taken over by the military and provided care for those wounded on the Western Front. Now closed, the site is undergoing redevelopment, with this view showing the former water tower.

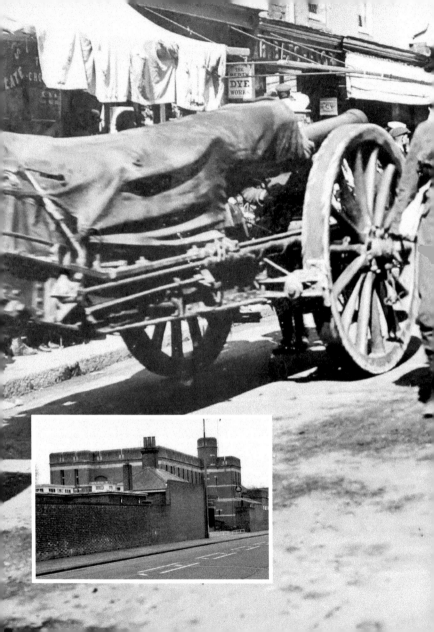

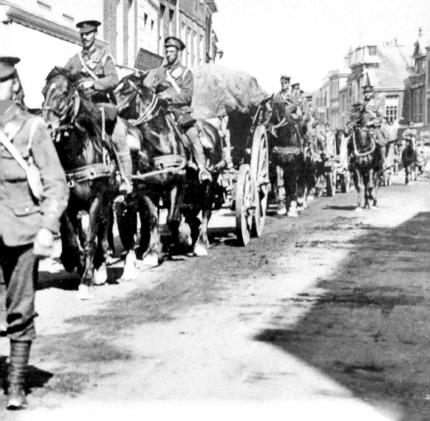

18. CHICHESTER BARRACKS

Initially constructed in 1795, the Barracks in Broyle Road (*inset*) have undergone several periods of enlargement prior to a final closure and conversion into a residential estate. Home to various regiments throughout its years of military service, members of the Royal West Sussex Regiment are to be seen in the main picture (*c.* 1905). Having left the barracks earlier in the day, they are seen proceeding through North Street en route for a summer manoeuvres encampment.

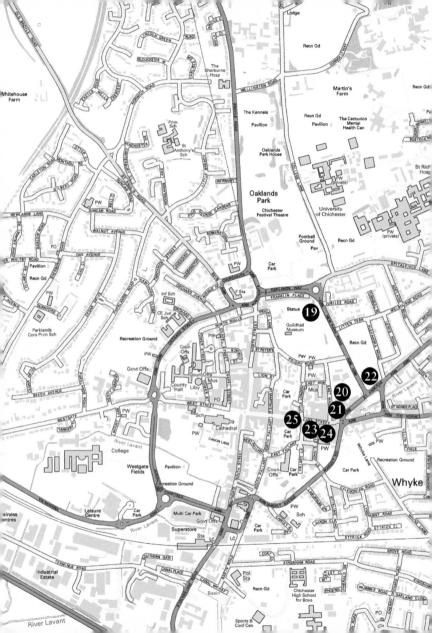

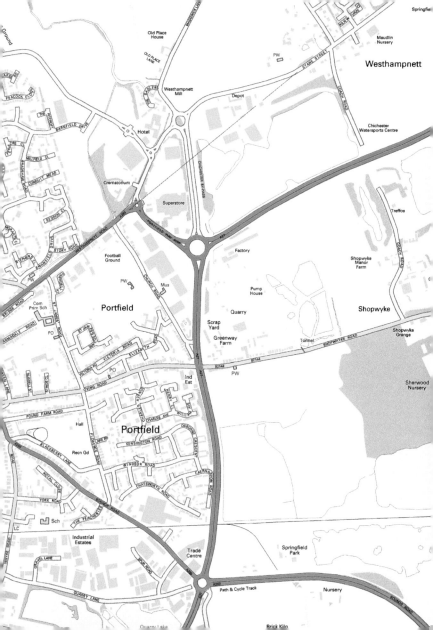

19. CITY WALLS

The city walls date to Roman times and were pierced with gates at each of the four cardinal points of the compass. Due to various road widening schemes over the passing centuries, these gates have long since ceased to exist, although attempts were made to replicate these gates as part of the celebrations held for the coronation of George V (1911).

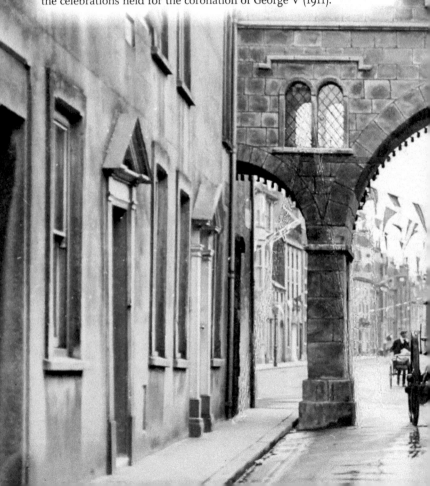

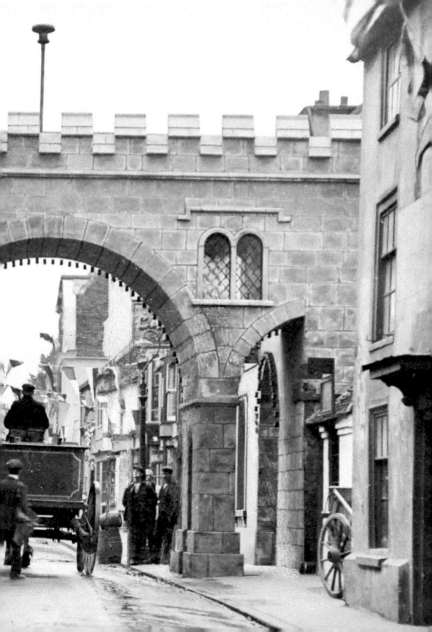

20. ART HOUSE CINEMA

Originally the Chuch ofEngland Central School and constructed during the 1880s, this building alongside NewPark Road currently houses a highly popular Art House Cinema and regularly shows films in the two former classrooms of the school.

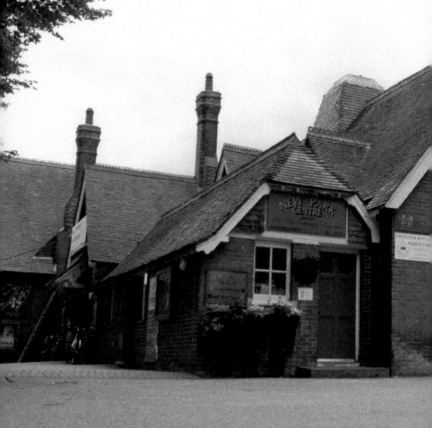

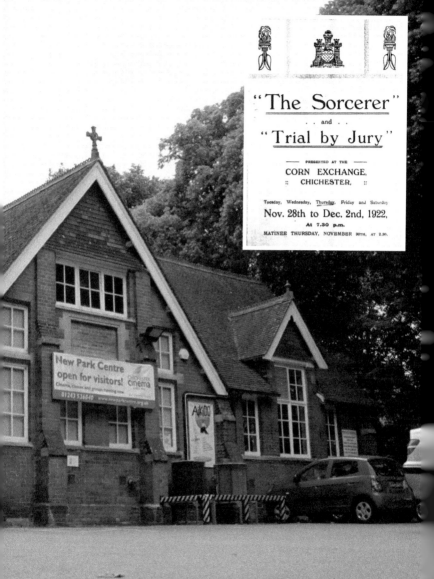

"The Sorcerer"
. . and . .
"Trial by Jury"

—— PRESENTED AT THE ——

CORN EXCHANGE,
:: CHICHESTER, ::

Tuesday, Wednesday, Thursday, Friday and Saturday

Nov. 28th to Dec. 2nd, 1922,

At 7.30 p.m.

MATINEE THURSDAY, NOVEMBER 30TH, AT 2.30.

New Park Centre
open for visitors!
CHICHESTER cinema
Cinema, classes and groups training now.
01243 516640 www.newparkcinema.org.uk

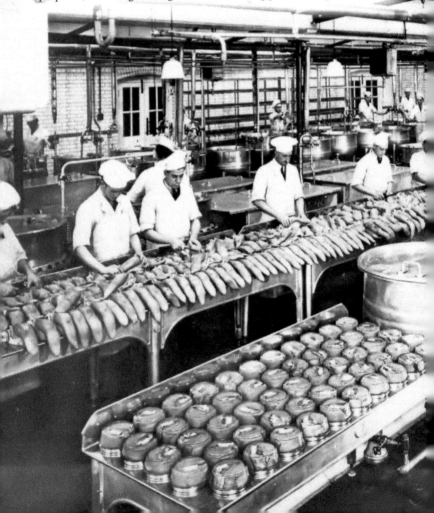

21. SHIPPAM LIMITED

A general view of work underway in Shippam's East Walls factory, built shortly before the First World War. Here a range of food stuffs was prepared, including ox tongue, seen here being placed into glass moulds.

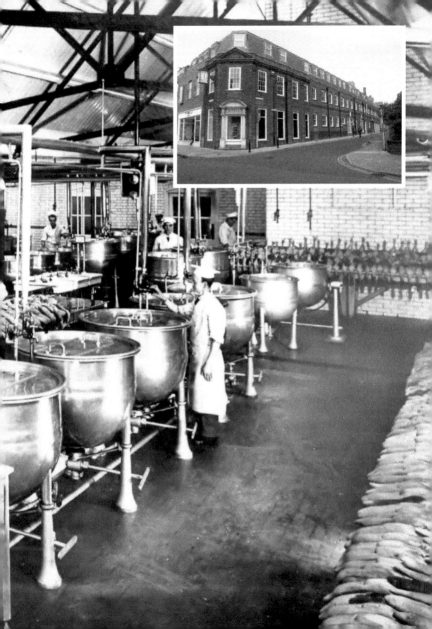

22. WAR MEMORIAL

Originally the Chichester war memorial (*inset*) stood in Eastgate Square and was unveiled in July 1921. It was moved to its present site in Litten Gardens, alongside New Park Road, in November 1940 to allow for road widening. In pursuing its desire for peace and to not forget their fallen comrades, Armistice Day in Chichester was an important occasion of remembrance. In the main picture, members of the Sussex Regiment are attending the Armistice Day service held at the cathedral sometime during the 1920s. A separate service was also regularly held at the war memorial in Eastgate Square.

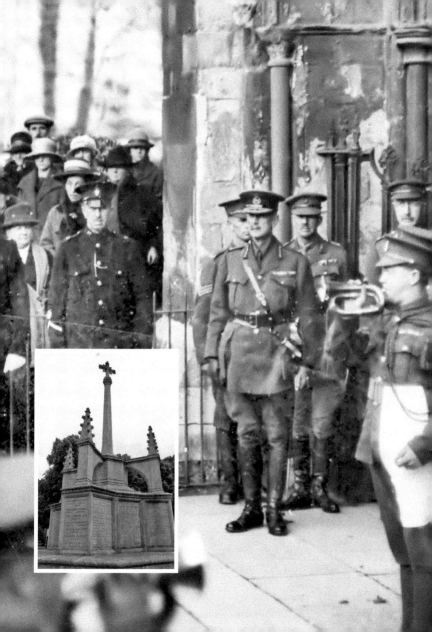

23. CORN EXCHANGE

Among the most impressive of the city buildings is the Corn Exchange, located at the far end of East Street. Completed in 1833, it was designed as a public market for easing the transaction of locally harvested corn. Samples were held in various pitchers, allowing bidders to gain a sample of the quality of the produce they were to purchase. In the photograph, probably taken in 1946, is an A-board informaing passersby that the film being shown is *When the Sun Shines*, best describes as a mild wartime comedy.

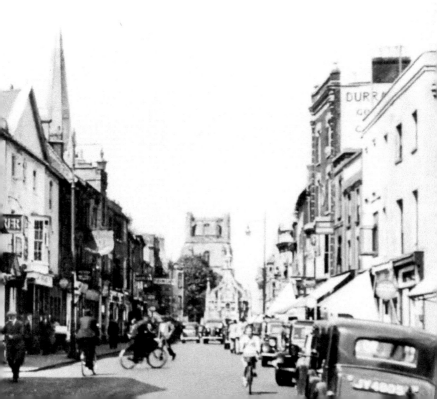

24. EASTGATE SQUARE

An interesting mix of new and old exists in Eastgate Square, the tower of St Pancras church being in the middle of a new development marketed as The Square. St Pancras, although having a medieval appearance, was actually built between 1850 and 1851, albeit on the site of an earlier church.

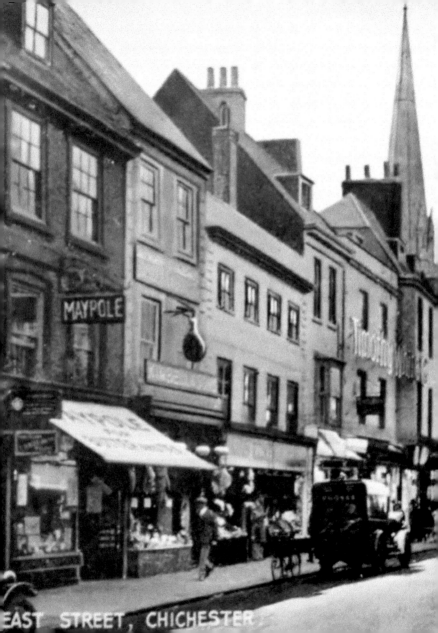

MAYPOLE

EAST STREET, CHICHESTER

25. EAST STREET

East Street on a summer's morning in 1932. Among shops on the south side of this street are Maypole Dairy, Kimbell & Son and the chemist's, Timothy White. As regards this last shop, Timothy White, this was later subsumed into Boots with the site now occupied by Topshop. On the opposite side of the street are the Westminster Bank (now NatWest) and Jay's, an ironmonger (nearest to camera).

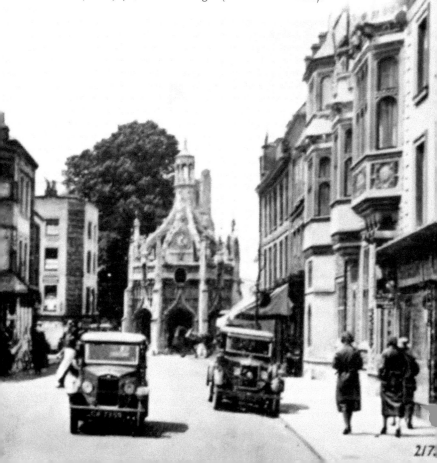

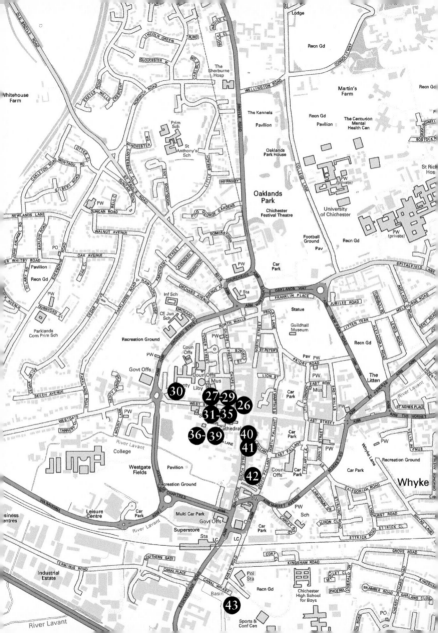

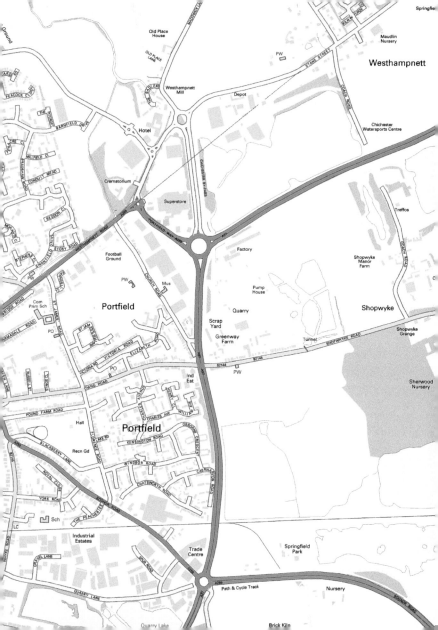

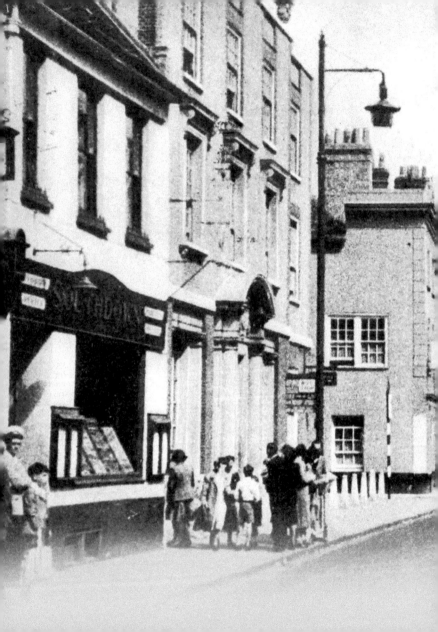

26. WEST STREET

West Street skirts the quietest quadrant of the city, the one dominated by the cathedral. However, it is also a main stopping point fot buses, a role that it has held for a good many years. This illustration provides a flavour of the street in a time when buses serving the city were decked out in the familiar livery of Southdown Motor Services.

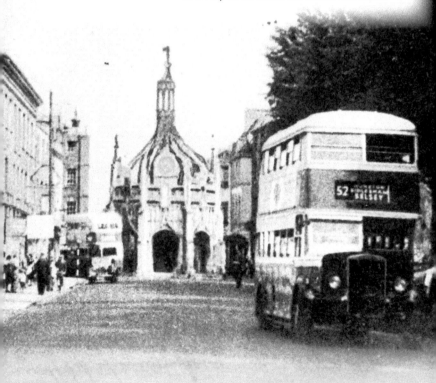

27. THE DOLPHIN & ANCHOR

The Dolphin & Anchor were two separate inns that were combined in 1910. Originally the Dolphin was a coaching inn that, as far as the current building is concerned, dates to a rebuilding that took place in 1768. In more recent years, the part of the building that was the Dolphin has been converted into separate retail outlets.

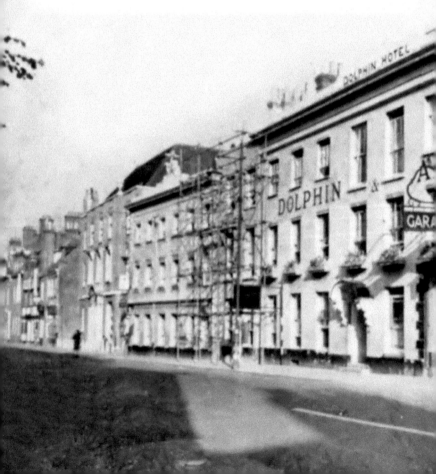

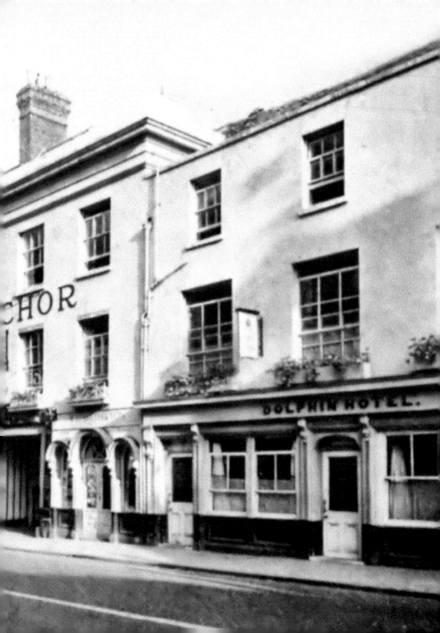

28. OLIVER WHITBY SCHOOL

An early eighteenth-century addition to the city was the Oliver Whitby School in West Street. However, the present-day building dates to 1904 with the school closing in 1949. Since that date, the original building has been acquired as a retail outlet.

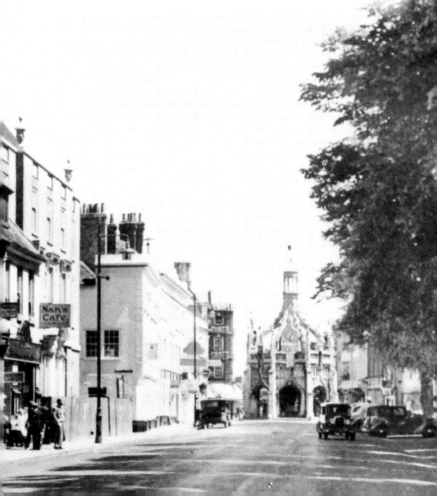

29. ST PETER THE GREAT

Also known as the Sub-Deanery, the church of St Peter the Great in West Street was the largest of the parish churches in Chichester, providing seating for a congregation of 600. With its foundation stone laid in August 1848, it is of the early Decorated style and was constructed to free the nearby cathedral of its parish duties, those who lived in the area served by the Sub-Deanery having once been accorded an altar within the cathedral. A dwindling congregation, and the need to carry out extensive repairs, led to the sale of the building in 1979.

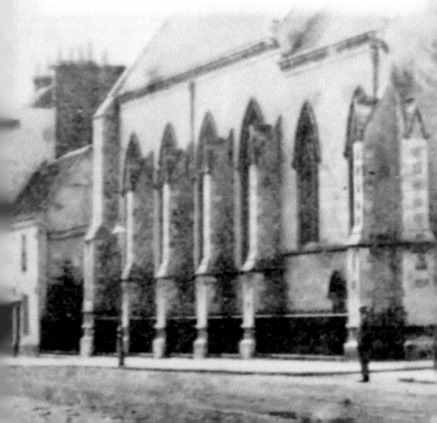

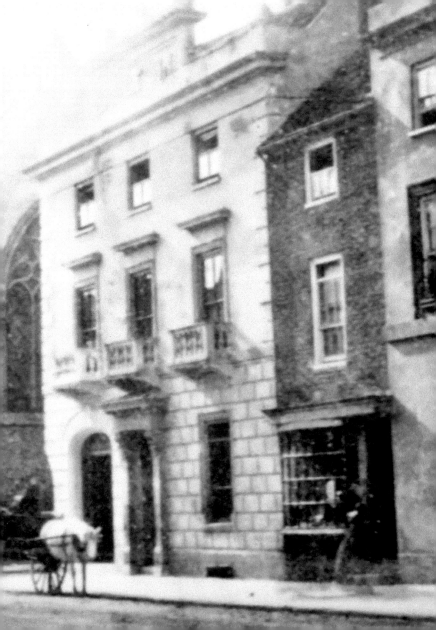

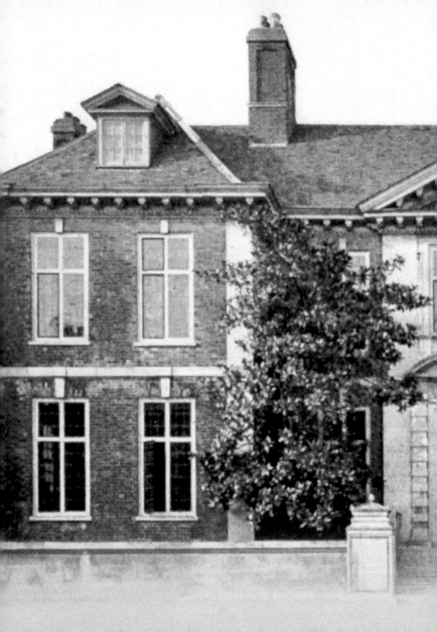

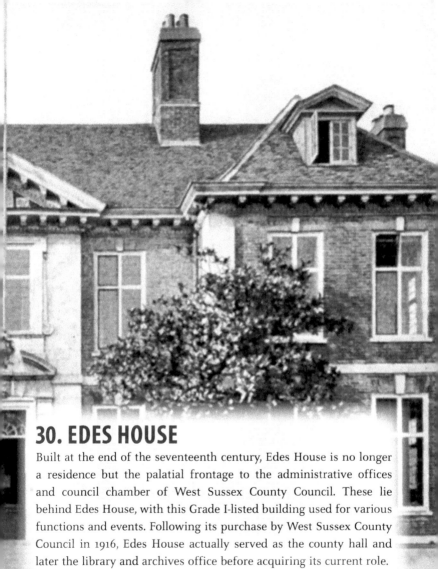

30. EDES HOUSE

Built at the end of the seventeenth century, Edes House is no longer a residence but the palatial frontage to the administrative offices and council chamber of West Sussex County Council. These lie behind Edes House, with this Grade I-listed building used for various functions and events. Following its purchase by West Sussex County Council in 1916, Edes House actually served as the county hall and later the library and archives office before acquiring its current role.

31. THE CATHEDRAL

Medieval Chichester was well served spiritually. The area of the city was divided into a number of separate parishes, each having its own church or place of prayer. The cathedral, of which the core building dates back to Norman times, has undergone many alterations, exhibiting fine examples of many differing periods of architecture.

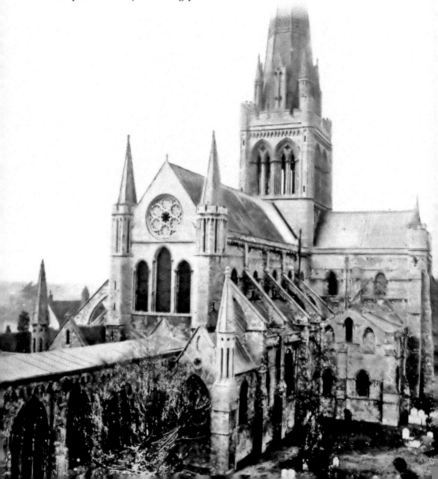

32. THE NEW TOWER

In February 1851, tragedy struck the cathedral when the central tower and spire collapsed. Caused by the weight of the tower, which had been heightened in the thirteenth century, it was an event that was only long delayed in its happening. Fortunately, it took place during a time when the building was empty, for if it happened during the time of a service, the outcome would surely have been unimaginable. Following the collapse, the present-day tower and spire were constructed, with work completed in 1866.

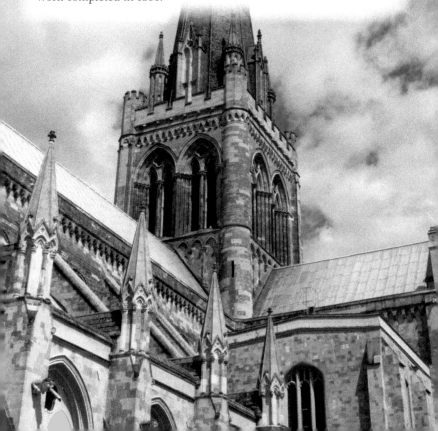

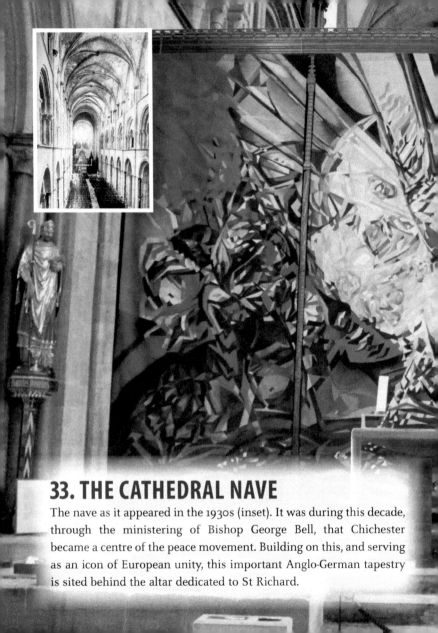

33. THE CATHEDRAL NAVE

The nave as it appeared in the 1930s (inset). It was during this decade, through the ministering of Bishop George Bell, that Chichester became a centre of the peace movement. Building on this, and serving as an icon of European unity, this important Anglo-German tapestry is sited behind the altar dedicated to St Richard.

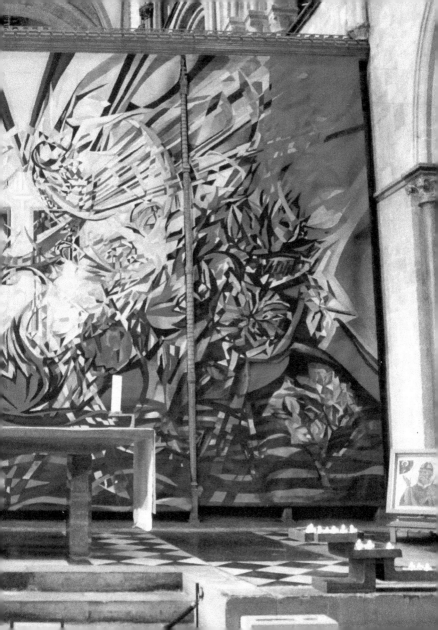

34. CATHEDRAL CLOISTERS

The cloisters of the cathedral date to around the year 1400 and are in the medieval decorated Gothic style. At one time, as can be seen from the photograph, the cloisters provided space for a cemetery, with those who lived in the parish once served by the building being among those who were buried here.

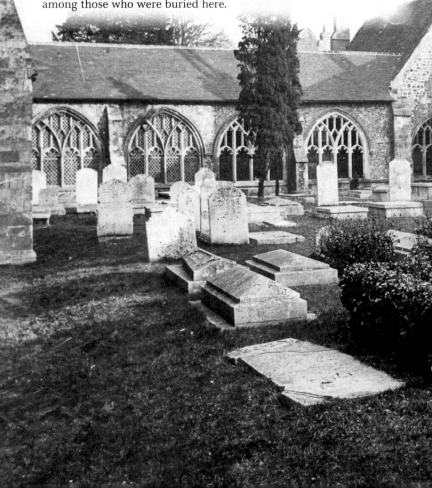

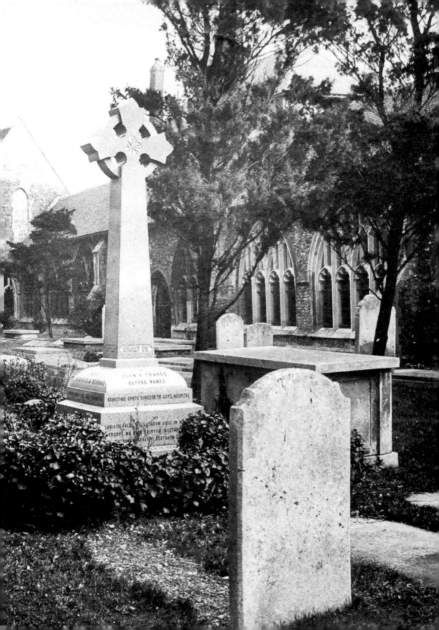

35. BELL TOWER

A particularly distinctive feature of Chichester is the detached bell tower that stands alongside West Street. While many of the English medieval cathedrals once possessed such a feature, the one at Chichester is the only surviving example. Dating to the fourteenth century, it can by no means be described as attractive, but its uniqueness gives it an unrivalled historical significance.

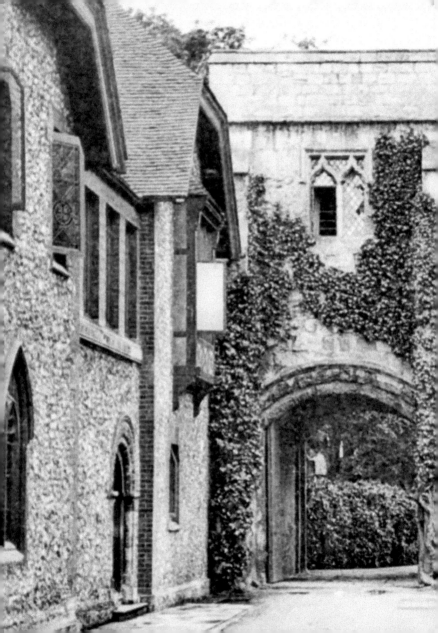

36. GATEWAY TO THE BISHOP'S PALACE

In common with the Bell Tower, this structure also dates to the fourteenth century. Originally it was conceived as a means by which those of the cathedral could live a more exclusive lifestyle that would keep them from unnecessary contact with their troublesome secular neighbours.

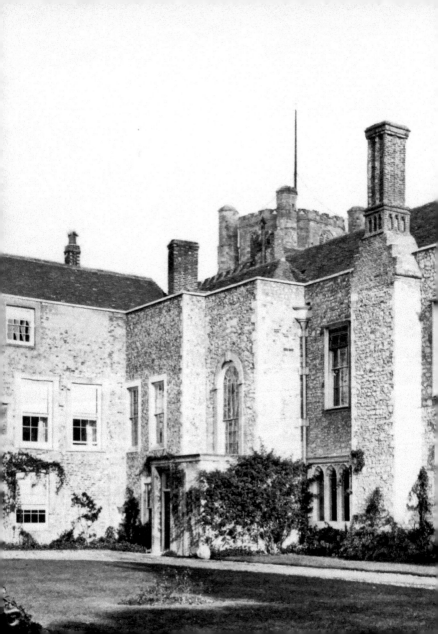

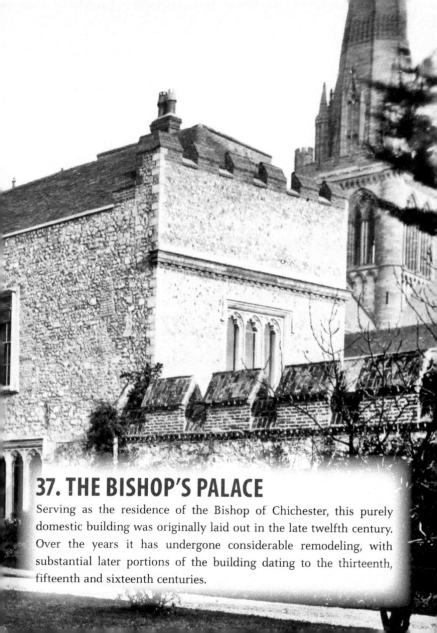

37. THE BISHOP'S PALACE

Serving as the residence of the Bishop of Chichester, this purely domestic building was originally laid out in the late twelfth century. Over the years it has undergone considerable remodeling, with substantial later portions of the building dating to the thirteenth, fifteenth and sixteenth centuries.

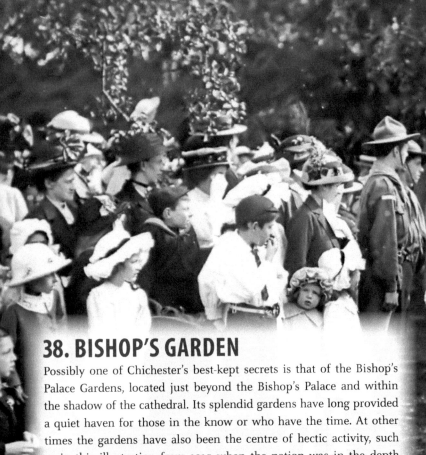

38. BISHOP'S GARDEN

Possibly one of Chichester's best-kept secrets is that of the Bishop's Palace Gardens, located just beyond the Bishop's Palace and within the shadow of the cathedral. Its splendid gardens have long provided a quiet haven for those in the know or who have the time. At other times the gardens have also been the centre of hectic activity, such as in this illustration from 1915 when the nation was in the depth and horrors of war, a pageant held in the gardens that was nothing less than a thinly disguised military recruiting campaign. Somewhat controversially, or at least by contemporary standards, the Anglican Church in the city was very keen to encourage parishioners to fight on the Western Front, with the clergy at all levels unhesitant in their encouragement of parishioners to get into uniform.

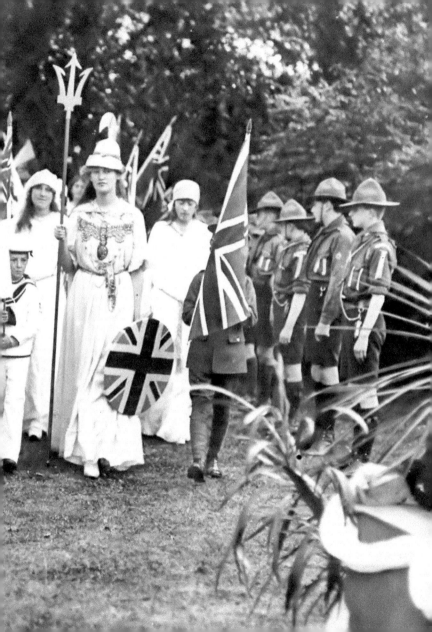

39. A WALK IN THE PARK

The Bishop's Palace Gardens on peaceful and less warlike occasions. A children's nurse during the 1920s (main picture) takes advantage of a warm summer's day while the many shrubs bloom in the present-day gardens (*inset*).

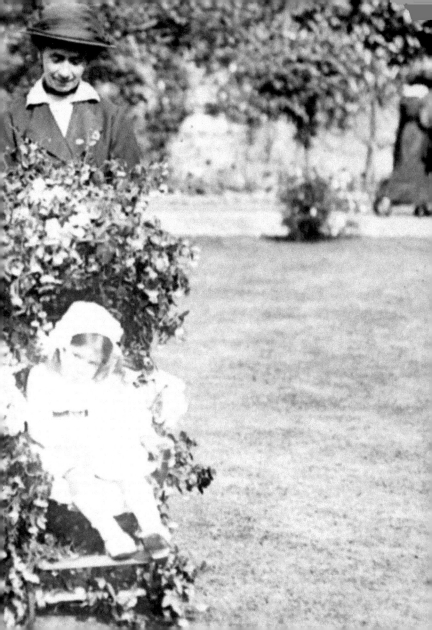

40. CANON LANE GATE

On exiting the Cathedral Close through Canon Lane Gate, South Street is reached with its numerous small shops on either side. When this picture was taken, possibly in the 1920s, the shop immediately to the right was Wilfrid W. Bartholomew, a tobacconist who obviously did a good line in Will's Gold Flake. The other two shops in the picture are S. J. Linkins (a sports outfitter) and The City Fruit Stores. Currently occupying the site next to Canon Gate is a small gift shop.

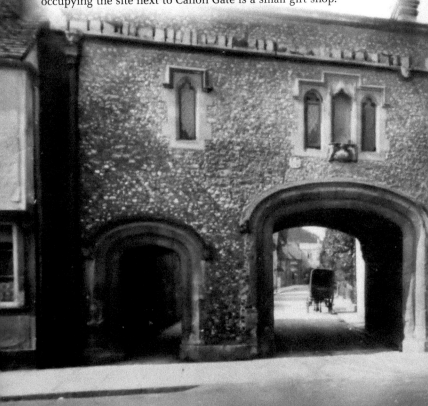

Canon Lane Gate, leading to the Close, Chicheste

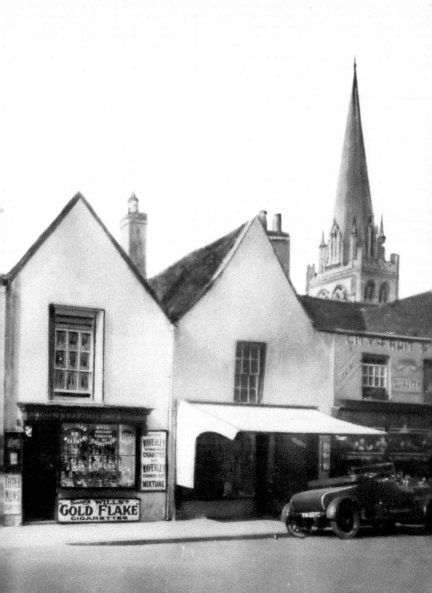

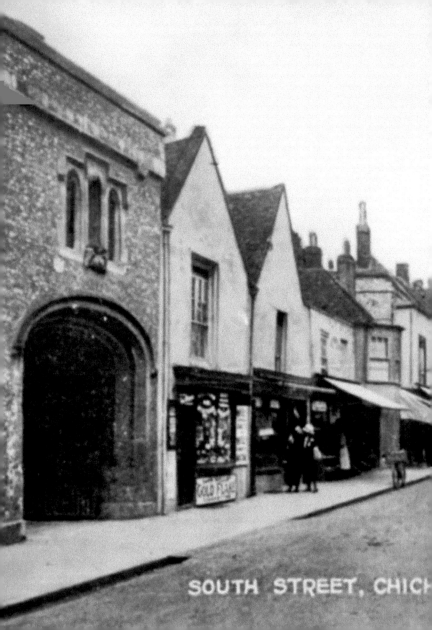

SOUTH STREET, CHICH

41. SOUTH STREET

A general view of South Street looking north towards the Market Cross and seen during the autumn of 1924. Once again, the Canon Gate and its adjoining tobacconist shop are to be seen. On the opposite side of the street are the offices of the *Sussex Daily News* and *Evening Argus* (No. 56 South Street) and C. C. Allen & Sons, a jeweller of Nos 57–59 South Street. The *Sussex Daily News*, once read widely in the city, ceased publishing in 1956. This building became a Pricerite supermarket in the late 1960s, remaining a supermarket, albeit with a different name, until the present day – it is currently part of the Iceland chain of stores.

STER.

92109

42. CHICHESTER THEATRE

A building of especial importance for the history of Chichester is a small building, now a restaurant, on the corner of South Street and Theatre Lane. As originally constructed, this was a **purpose-built** theatre that first opened its doors in May 1792 with **a performance of** *The Siege of Belgrade*.

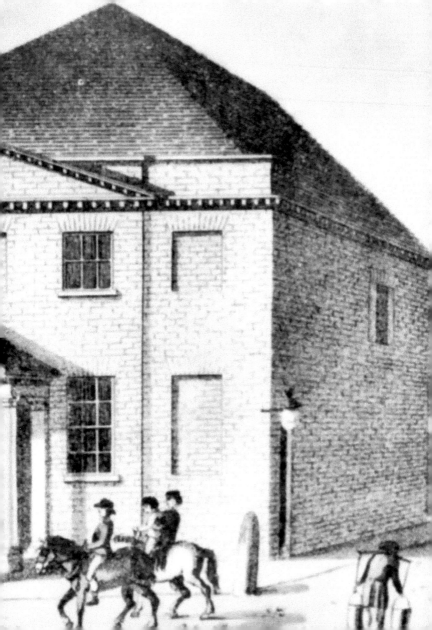

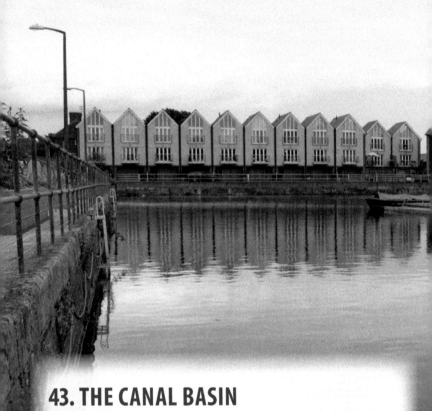

43. THE CANAL BASIN

The canal basin was an important facility for local merchants during the early nineteenth century, allowing cargoes to be loaded onto barges that could then make their way to various inland markets across the country. The Basin is at the end of a specially-cut waterway that leads to Hunston, where it then connects to Portsmouth–Arundel Canal.